Script Lettering

D1138275

Script Lettering

M. Meijer

BLANDFORD PRESS
POOLE NEW YORK SYDNEY

First published in U.K. in 1956 by
Blandford Press, Link House,
West Street, Poole, Dorset BH15 1LL

Second edition 1964
Reprinted 1984
Reprinted 1986
Reprinted 1987

Copyright © 1956 and 1964 Blandford Press Ltd.

Distributed in the United States by
Sterling Publishing Co. Inc.,
2 Park Avenue, New York, N.Y. 10016.

Distributed in Australia by
Capricorn Link (Australia) Pty Ltd.,
PO Box 665, Lane Cove, NSW 2066

ISBN 0 7137 1435 2

All rights reserved. No part of this book may be
reproduced or transmitted in any form or by any
means, electronic or mechanical, including
photocopying, recording or any information
storage and retrieval system, without
permission in writing from the Publisher.

Printed in Great Britain by Hollen Street Press
Ltd, Slough, Berks.

Contents

Introduction

Script Lettering in its many forms and styles is extensively used in all forms of commercial art and advertising. Its design is stimulating and it is quickly readable. Its moods vary between a sense of urgency and a quiet elegance.

Script covers a wide field from the formal style of copperplate and the dignity and restraint of the old styles to the free flowing calligraphic lettering that approaches character handwriting. There is also a style which is based on the italic letter.

In addition to using the original alphabets in these pages, the lettering artist can, of course, develop his own script forms, which can be both interesting and creative work.

The tools and materials are important. Of course, needs differ from person to person and according to the type of work, from sign writing in oils to indian ink work for advertisement headlines; but a good basic selection might be: -

1. Drawing board.
2. A set square (bevelled).
3. A tee square—though this is not at all essential.
4. Black indian ink—and process white for re-touching.
5. Brushes. One medium size, perhaps No. 4 or No. 5, with a really good point, for the majority of the work, a fine one (No. 1) for very small work and re-touching, and a large one (about No. 6 or No. 7) for bold, racy dry brush effects. Camel hair brushes are recommended. It is worth getting the best brushes and then taking trouble to keep them in good condition. Indian ink should always be washed out with a little soap, as if allowed to dry on the brush it quickly rots the hairs.
6. Pens. There are many types to choose from. Almost certainly, a set of broad nib pens, and a fine 'mapping pen'. A round tipped pen is useful for poster work. There are so many types of pens that the serious student would be advised to study a book specialising in that sort of lettering.
7. Lettering boards. For best work, smooth Bristol board is recommended, though Ivory board and Fashion boards are quite satisfactory for general work, and for a dry brush effect a rough Whatman surface is good. A layout pad of thin bond paper is often very useful.
 Also useful are a good soft rubber, hard pencil, steel ruler, rubber gum (for mounting) and so on.

Type founders script, which is the concern of the second section, is of utmost importance in modern typography and advertising. There is such an extensive selection of script type available to-day that the hand lettering for the advertisement for printed matter is no longer so essential as it was once thought to be. Modern script types are so designed and produced that they are just as effective and often almost as free and adaptable as the hand lettered material. All the typographer need do is to specify the type he chooses to the printer, providing of course the latter has it in stock or can get it.

The type founders have overcome the problem of continuous flow of the lettering, which is so necessary in most forms of script, and the choice ranges from copperplate to free brush.

The selections given are but representative of a wide range of script types available. In the 'Encylopaedia of Type Faces' there are more than one hundred and fifty script types listed and illustrated, but those which have been selected here are fairly representative of the range.

Script Lettering

ABCDEFJ
GHIKLMN
OPQRSTU
* VWXYZ *

abcdefghijklmno
pqrst-uvwxyz

ABCDEFJ
KLMNQR
STUVWX
YZ

abcd efgh
ijklmnopqrst
uwxyz

ABCDEFGHJK
LMNOPQRS
TUVWXYZ

abcdefghijkln
mopqrstuw
vxyz

abcdefgihjklmno
pqrstuvwxyz

ABCDEFGHIJ
KLMNOPT
QRSUVX
+WYZ+

ABCDEFG
HIJKLMNO
PQRSTUW
VXYZ

abcde
fghijklmnopq
rstuvwxyz **

11

abcdefghijklmn

opqrstuvwxyz..

ABCDEFG

HIJKLMN

OPQRSTU

VWXYZ.

ABCDEFG
HIJKLMNOP
QRSTUVWXY
Z

abcd efgh
ijklmnopqrstuv
wxyz

abcdefghijklmn
opqrstuvwxyz

ABCDEFG
HIJKLMN
OPQRSTU
VWXYZ

abcdefghijklmnopq
rstuvwxyz

ABCDEFGHI
JKLMNOPQR
STUVW
XYZ

Aa Bb Cc
Dd Ee Ff Gg Ii
Jj Kk Ll Mm Nn
Oo Pp Qq Rr Ss
Tt Uu Vv Ww Xx Zz

ABCDEFG
HIJKLMNO
PQRSTUV
WXYZ

abcdefghijkl
mnopqrst
uvwxyz

abcdefghijklm
nopqrstuvwxz

ABCDEF
GHIJKLM
NOPRSTU
VWXYZ

abcdefghijklmn
opqrstuvwxyz .

ABCDEFGI
HIJKLMNO
PQRSTUVW
XYZ

ABCDEFG
HIJKLM
NOPQRST
UVWXYZ

abcdefghijklmno
pqrstuvwxyz

ABCDEFGI
HIJKLMNO
PQRSTUW
VXab hiYZ

cdefg
jklmnopqrstuvwxyz

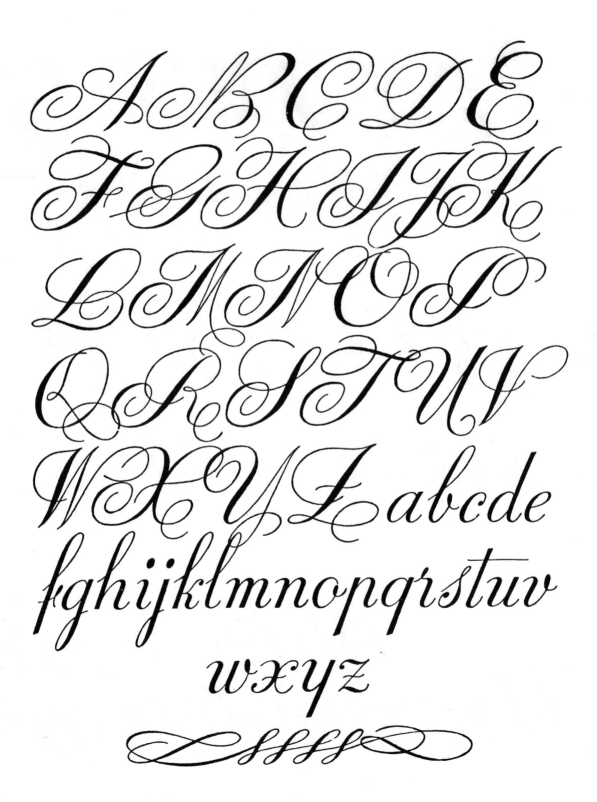

ABCDEFG
HIJKLMN
OPQRSTUV
WXYZ

abcdefghijklmn
opqrstuvwxyz

ABCDEFG
HIJKLMN
QPRSTUV
WXYZ

abcdefgh
ijklmnopqrstuvw
xyz

A B C D E F G H

I J K L M N O P

Q R S T U V W X

Y Z

a b c d e f g h i j k

l m n o p q r s t u v w x y z

ABCD
EFGHIJ
JKLMN
OPQRS
TUVWX
YZ

abcdefghijkl
mnopqrstuvwxyz

ABCDEFGH
JKLMNOPQ
RSTUVWXYZ

abcdefghijklm
nopqrstuvwxz

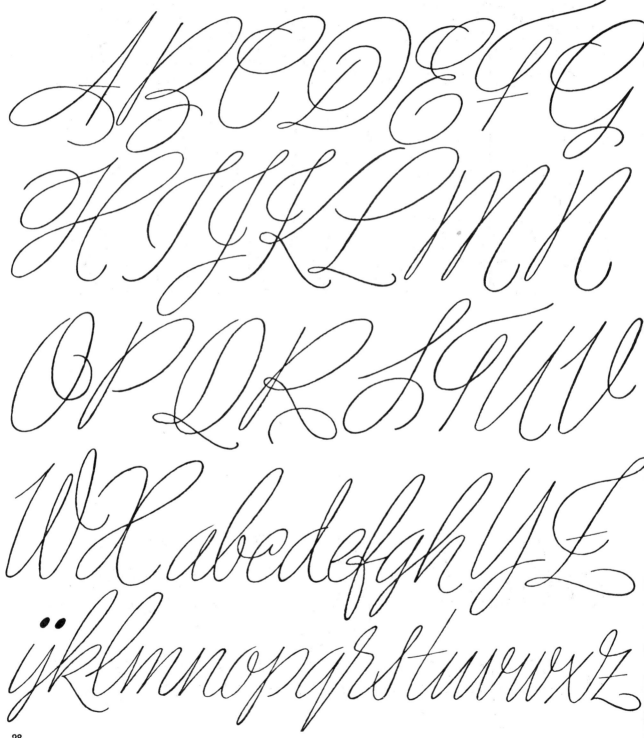

ABCDEFGH
JKLMNO
PQRSTUVW
XYZ

abcdefghijklmnopq
rstuvwxyz

abcdefghijklmn

opqrstuvwxyz *

ABCDEFGH

IJKLMNOPQ

RSTUVWYZ

ABC
DEFGHIJK
LMNOPQRS
TUVWXYZ

abcdefghijklmnopq
rstuvwxyz

abcdefghijklmn
opqrstuvwxyz

ABCDEFG
HIJKLMNO
PQRSTUW
VXYZ

ABCDEFGH
IJKLMNOP
QRSTUVWXY
Z

abcdefg hijklmn
opqrstuvwxyz

ABC
DEFGHIJKLMN
OPQRSTUVW
XYZ

abcdefghijklmnopr
stuvw qxyz

ABCDEF
GHIJKLM
NOPQRS
TUVWXYZ

abcdefghijklm
nopqrstuvwxz

ABCD
EFGHIJK
LMNOPQ
RSTUVWX
Y
Z

abcdefghijkl
mnopqrstuvwxyz

abcdefghijk
lmnopqrstuvw
xyz
ABC DEF
GHIJKLMNO
PQRSTUVW
XYZ

ABCDEF
GHIJKLM
NOPQRST
UVWXYZ
abcdefghijkl
mnopqrstuvw
xyz

Script type faces are based on cursive or any form of handwriting. As early as the sixteenth century there was a script letter known as 'Secretary' and it was based on Elizabethan Gothic. In types available to-day, there is one based on French cursive, which was first cut at Lyons in 1557; it is called 'Civilité', and is near in design to the original English 'Secretary' and is reproduced below.

The 'Old English' or 'Abbey' texts, which were used by the monks in manuscripts, are little used to-day. The demand in commercial art and advertising is for the free flowing brush and pen letters or caligraphic forms.

The examples given in the following pages are reproduced from 'The Encyclopaedia of Type Faces' published by Blandford Press.

CIVILITÉ
American Typefounders 1922

Designed by M.F. Benton. Based on the French cursive first cut by Robert Granjon at Lyons in 1557. It corresponds to the script type 'Secretary' of the sixteenth century.

GRAPHIC SCRIPT BOLD
Bauer 1934

Designed by Ernst Schneidler. A nineteenth century copperplate script.

A A B C D E F F G G H H I
J K K L M M N N O P Q Q R
S S T U V W X Y Z 1234567890
abcdefghijklmnopqrstuvwxyz e h l r s t z

KUNSTLERSCHREIBSCHRIFT
Stempel 1957

This script has the design of a copperplate in a bold weight.

A B C D E F G H I J K L M
N O P Q R S T U V W X Y Z
abcdefghijklmnopqrstuvwxyz

DORCHESTER SCRIPT
Monotype 1938

A visitingcard script. A nearly upright type with curly capitals. The lower case has looped ascenders and long descenders.

A B C D E F G H I J K L M N

O P Q R S T U V W X Y Z &

abcdefghijklmnopqrstuvwxyz

COPPERPLATE BOLD
Stephenson Blake 1953

A bold face of the English copperplate script.

A B C D E F G H I J K L M N O

P Q R S T U V W X Y Z

abcdefghijklmnopqrstuvwxyz

1 2 3 4 5 6 7 8 9 0

41

RONDO
Amsterdam 1948

Designed by Stefan Schlesinger and Dick Dooijes. The flourished capitals have some resemblance to those of the traditional French Ronde, but not the lower case. The variation of colour is small, ascenders and descenders are short and there are no looped letters. The type has a slight inclination. There are two weights.

$$ABCDEFGHIJKLMNOPQuRST$$
$$UVWXYZ$$

abcdefghijklmnopqrstuvwxyz 1234567890

$$ABCDEFGHIJKLMNOPQuRST$$
$$UVWXYZ$$ abcdefghijklmnopqrstuvwxyz

THOMPSON QUILLSCRIPT
American Typefounders 1953

Designed by Tommy Thompson. A calligraphic script with slight inclination.

$$ABCDEFGHIJKLMNOPQRSTUVWXYZ\&$$
$$1234567890\$abcdefghijklmnopqrstuvwxyz$$
$$AAEFGHIKLMNTVW\&fh$$

RONDINE
Nebiolo

A formal script of medium weight. The capitals are freely drawn, and in the lower case the ascenders are tall and looped.

ABCDEFGHIJKLMNOPQuRS
TUVWXYZÇÆŒ
abcdefghijklmnopqrstuvwxyzçœœ
1234567890

SINFONIA OR STRADIVARIUS
Bauer 1945

Designed by Imre Reiner. An unusual script with flourished capitals and a stiff lower case. There is considerable variation of colour. Ascenders are tall and there are no serifs. The rigid appearance is produced by the squaring of normally round letters.

ABCDEFGHIJKLMNOPQ
RSTUVWXYZ abcdefghijklmnopqrstuvwxyz
1234567890

GRAPHIK OR HERALD
Bauer 1934

Designed by F.H.E. Schneidler. A bold, slightly inclined script following the style of other German bold display scripts.

ABCDEFGHIJKLMNOPQRSTUVWXYZ

abcdefghijklmnopqrstuvwxyz 1234567890

MERCURIUS
Monotype 1957

Designed by Imre Reiner. A heavy brush script of very angular design.

ABCDEFGHIJKLMNOPQ
RSTUVWYZ
abcdefghijklmnopqrstuvwxyz

REPORTER
J. Wagner 1938

Designed by C. Winkow. An informal script of medium weight which is slightly shaded.

ABCDEFFIGHJJKLMNOPQÜRSSchSTTh
UVWXYZ 1234567890
aäubcdeeienerentfffifift ghhchheitijkckkeit

MISTRAL
Olive 1955; Amsterdam Typefoundry 1953

Designed by Roger Excoffon. An informal, true script.

ABCDEFGHIJKLMNOPQRSTUVWXYZ
abcdefghijklmnopqrstuvwxyz
1234567890

GILLIES GOTHIC OR FLOTT
Bauer 1935

Designed by W.S. Gillies. A script monotone in colour with flowing capitals and a more rigid lower case.

ABCDEFGHIJKLMNOPQRSTUVWXYZ
abcdefghijklmnopqrstuvwxyz Th 1234567890

REINER BLACK
Berthold 1955

Designed by Imre Reiner. A strong brush script.

ABCDEFGHIJKLMNOPQRSTUVW
XYZ&$£1234567890
abcdefghijklmnopqrssttthuvwxyz

HOLLA
Klingspor 1932

Designed by Rudolf Koch. A quill pendrawn script of medium weight.

ABCDEFGHIJKLMNOPQRSTUV

abcdefghijklmnopqrstuvwxyz

1234567890

BCDEFGIKOUVWY

SALTINO
Klingspor 1953

Designed by Karlgeorg Hoefer. An informal Latin script of heavy weight and considerable variation of stress.

ABCDEFGHIJKLMNOP

QRSTUVWXYZ

abcdefghijklmnopqrstuvwxyz

AMÉTHYSTE
Deberney & Peignot 1954

Designed by Georges Vial. An irregular script with much variation of stress and tall ascenders.

$$ABCDEFGHIJKLMNOPQRSTUVZ$$

$$abcdefghijklmnopqrstuvwxyzœ \quad ? \quad 24680!$$

BOLIDE
Deberney & Peignot 1954

Designed by Georges Vidal. A heavy informal script with uneven outlines.

$$ABCDEFGHIJKLMNOPQRSTU$$

$$VWXYZŒ$$

$$abcdefghijklmnopqrrsstuvwxyz:æ$$

DISCUS
Stempel 1955

Designed by M. Wilke. A formal script with moderate variation of stress and slight inclination.

ABCDEFGHIJKLMNO

abcdefghijklmnopqrstuvwxyz

1234567890

ABCDEFGHIJKLMNO

abcdefghijklmnopqrstuvwxyz

PALOMBA
Weber 1955

Designed by Georg Trump. A script of heavy weight with flourished capitals and an upright lower case. Ascenders are tall and the letters have a pen-drawn quality with little variation of colour.

ABCDEFGHIJKLMNO

PQRSTUVWXYZ

abcdefghijklmnopqrstuvwxyz

MURRAY HILL
American Typefounders 1956

Designed by E.J. Klumpp. A light script with swash capitals and an informal, condensed lower case. The letters are almost upright.

ABCDEFGHIJKLMNOPQRSTUV
WXYZ& abcdefghijklmnopqrstuvwxyz 1234567890

ABCDEFGHIJKLMNOPQRST
UVWX abcdefghijklmnopqrstuvwxyz
1234567890

FLUIDUM
Nebiolo 1951

A script in which the thin strokes are hair lines.

ABCDEFGHIJKLMNOPQRSTUVWXYZÇÆŒ
abcdefghijklmnopqrsstuvwxyzç æœ
1234567890